The Remembered Image

Cover (Fig. 18):
Monte Pincio, Rome, 1898–1899
Watercolor, 15½″ × 19¾″
Daniel J. Terra Collection,
Terra Museum of American Art

Back cover (Fig. 11):
*St. Mark's Square, Venice
(The Clock Tower)*, 1898–1899
Watercolor, 23½″ × 5¾″
William A. Farnsworth Library and
Art Museum, Rockland, Maine

Published in the United States of America
in 1987 by Universe Books
381 Park Avenue South, New York, N.Y. 10016

86 87 88 89 90 / 10 9 8 7 6 5 4 3 2 1

Printed in Hong Kong

ISBN 0-87663-509-5

Design: Marcus Ratliff Inc., New York
Typesetting: Trufont Typographers, Inc., New York
Color plates, printing and binding
by South Sea International Press, Hong Kong

The Remembered Image
Prendergast Watercolors 1896–1906

A loan exhibition for the benefit of
The Williams College Museum of Art

October 23rd to December 6th, 1986

Coe Kerr Gallery
49 East 82nd Street New York

Universe / Coe Kerr Gallery
New York

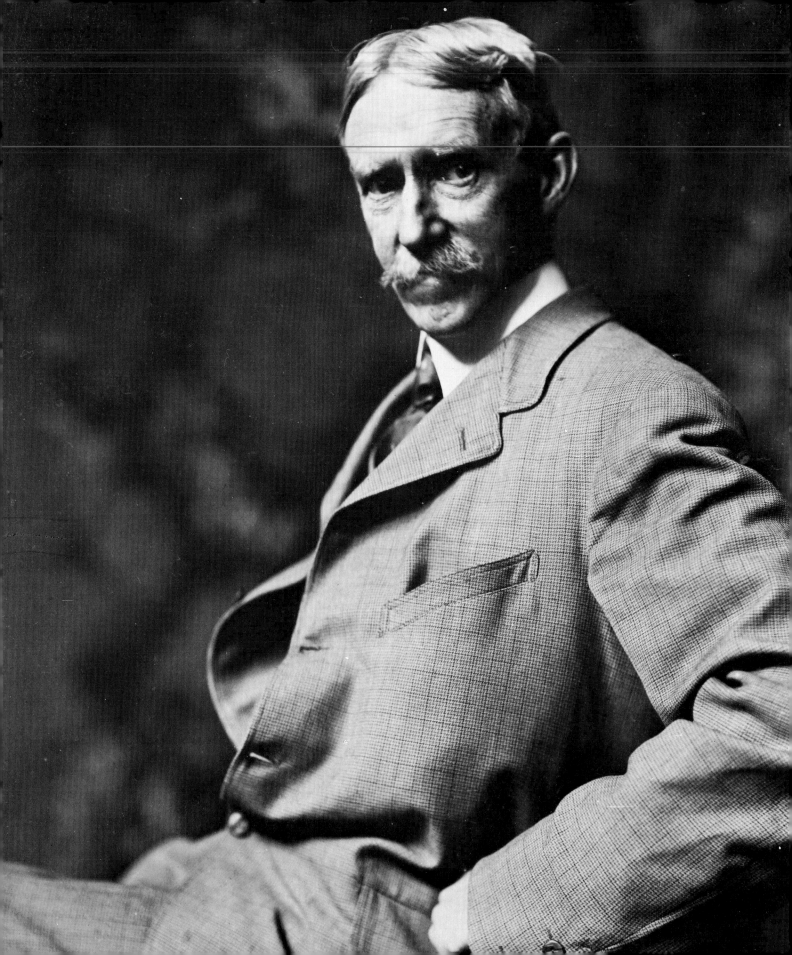

Acknowledgments

At the turn of the century, the American artist might have been an impressionist, an academic, or even a new realist turning his sights to the urban scene. The modernism of Europe was a decade away. In this context, Maurice Prendergast transcended all of his American contemporaries. Unfettered by the biases of academic training, this unusual and sensitive man blithely stepped over the rigors of classical training as well as the popularity of plein-air painting. Instead he was drawn to the theories of the Nabis and the tenets of synthetism; after the turn of the century, he was influenced by the other-worldly magic of Cézanne.

Prendergast did not share the conservative aesthetics of most Bostonians and New Yorkers of his day. Yet his great talent and appealing subjects allowed him to succeed where a lesser talent would have failed. Like his admirers of eighty years ago, we are dazzled by his color and light, his charm, his vitality. Whether it be the Public Garden in Boston, the beaches along Boston's south shore, the campos of Venice, or the crowds of Rome, his appeal is irresistible.

For some time we have wanted to present a small, jewel-like exhibition of Prendergast's watercolors that would be appropriate to their intimate scale and yet indicative of their range in subject and technique. We have assembled forty watercolors that span the decade 1896 to 1906; our selection gives a sense of the artist's variety and stylistic development during this period.

This has been an ambitious undertaking, owing to the difficulty of borrowing treasured pictures from their rightfully protective owners. But we have been very fortunate in the generosity of the lenders. Many are long-time and close friends of Coe Kerr Gallery; others have become new friends. We would like to extend special thanks to Margaret and Raymond Horowitz and to Rita and Dan Fraad. We were able to borrow two beautiful works from both collections. Another special debt of thanks is owed Ambassador Daniel J. Terra and the Terra Museum of American Art. We borrowed two works from the Terra Museum; one is reproduced on the cover of our catalog. Ambassador Terra has been an unrivaled champion of Prendergast's art, especially the works on paper.

Of course, without museum loans this exhibition would not have been possible. Our thanks to: Thomas Armstrong III, director, Whitney Museum of American Art; John Elderfield, director of drawings,

Frontispiece: Maurice Prendergast
Photograph by Kasebier, courtesy of the Pennsylvania Academy of the Fine Arts

Museum of Modern Art; John K. Howatt, Lawrence A. Fleischman Chairman of the Departments of American Art, Metropolitan Museum of Art; Laughlin Phillips, director, and Willem de Looper, curator, The Phillips Collection; Marius B. Peladeau, director, William A. Farnsworth Library and Art Museum; M. Jessica Rowe, director, Blanden Memorial Art Museum; Ambassador Daniel J. Terra, founder and chairman, and Michael Sanden, director, Terra Museum of American Art; and Martha Terrill, curator, Transco Energy Company.

This exhibition has been organized as a benefit for the Williams College Museum of Art. The Museum is the base of the Maurice and Charles Prendergast systematic catalogue raisonné project. Several participants in the project, including Carol Clark, Nancy Mowll Mathews, and Charles Parkhurst, have assisted us in organizing the checklist of this exhibition. We are also grateful to Thomas Krens, director, for suggesting that we coordinate our opening with that of the new wing of the Museum. Special thanks are extended to our longtime friend Jack Heineman, who has supported this project so enthusiastically from the outset.

The staff of Coe Kerr Gallery worked very hard in planning this project. Constance Gallant, our registrar, did an excellent job of gathering loans and photography. Leigh Morse organized the publicity for the show. Polly McGuire provided superb research assistance, ferreting out several important catalogs and articles. Arthur Prager edited the manuscript with great skill. Carol Flechner provided invaluable assistance as both copy editor and final manuscript editor. Donna Seldin, whose keen interest in Prendergast was the impetus for the exhibition, wrote the catalog essay.

This project gave us the opportunity of consulting with Mrs. Charles Prendergast on a variety of matters. Some had to do with details of Prendergast's life, others with amusing reminiscences, still others with the practical details of organizing the show. In all respects Mrs. Prendergast was gracious, supportive, and knowledgeable. We take special pleasure in dedicating both the exhibition and the catalog to her.

Warren Adelson, Director
Coe Kerr Gallery

The Remembered Image: Prendergast Watercolors 1896–1906

Maurice Prendergast's admirers delight in his simplicity, his vision of an idyllic world of holidays, picnics, and pageantry. At the same time, they praise his sophistication, the complexity of his style, and his dedication to the most advanced artistic tenets of his day. He was unique among late nineteenth-century American painters in welcoming the post-impressionist's view that art should be an amalgam of remembered and imagined images rather than a record of nature, and that color should be a formal decorative element in painting. Even though Prendergast painted familiar impressionist subjects with many details from everyday life, he did so in the spirit of Maurice Denis's declaration of 1890: "Remember that a painting—before it is a battlehorse, a nude woman or some anecdote—is essentially a flat surface covered with colors assembled in a certain order."

Prendergast was born in St. John's, Newfoundland, in 1859, the eldest son of people of modest circumstances. The family moved to Boston two years later. He got his first job at the age of fourteen wrapping packages in a dry-goods store and later became assistant to a painter of show cards. His chief pleasure was sketching, and his work from the early 1880s includes drawings of well-dressed ladies on whom he waited in the dry-goods shop and landscapes with grazing cows painted in the country south of Boston.

Prendergast did not leave Boston until 1886. In the summer of that year he and his brother Charles (1863–1948) worked their passage to and from England on a cattle boat. The brothers explored the English and Welsh countryside, but only a handful of minor sketches document their trip. Based on these, his first voyage abroad made little impact on Prendergast artistically. However, it did whet his appetite for foreign travel. Some months later he returned to Boston and to his job of lettering show cards, intending to stay only until he had saved enough money to return to Europe. This took longer than he had planned. It was not until 1891, six years later, that he came to Paris, where he began to study art.

His first instructor in Paris was probably Gustave Courtois at the Académie Colarossi. A year later, in 1892, Prendergast enrolled in a drawing class at the Académie Julian, but it soon became evident that his real education would come from Paris itself, its citizens, and its rich and innovative artistic community. He had no taste for drawing from antique casts at the Académie Julian but preferred to spend his afternoons sketching in the public gardens and along the boulevards.

The most fruitful aspect of Prendergast's student experience was his acquaintance with the Canadian painter James Wilson Morrice (1865–1924), who had entered the Académie Julian in 1890. The two painters must have been immediately attracted to each other. They shared an artistic affinity for street scenes and figure subjects spiced with a blend of humor and naïveté. Simplified arrangements in blocks of color emphasizing a revealing gesture characterize the Parisian works of both artists. These qualities reflect the influence of Whistler's Chelsea shop-front scenes and, in a more general way, the techniques of the Japanese printmakers so prized by the impressionists.

Morrice introduced Prendergast into the circle of British artists who were his friends. These included Aubrey Beardsley, Charles Conder, Roderick O'Connor, and Walter Sickert. The group met at a café in Montparnasse—Le Chat Blanc—and carried on lively discussions about the latest avant-garde trends. O'Connor, the theorist of the group, was especially interested in the ideas of Paul Gauguin (1848–1903) and in the work of Paul Cézanne (1839–1906), then a little-known painter from Provence.

Gauguin, who may have given some painting lessons at Colarossi's during this period, was forging the radical theories of synthetism. He advocated an art that favored intellectual conception, decorative arrangement, and simplification of forms and colors over the direct impression of nature. These aims agreed with Prendergast's own tendency toward decorative subjects and pure colors.

Gauguin's ideas were taken up by the secret society called the Nabis ("prophets" in Hebrew), active from 1888 to 1900. Its members were dedicated to the creation of an art that was at once intellectual, decorative, and mystical. The group included Maurice Denis (1870–1943), Édouard Vuillard (1868–1940), and Pierre Bonnard (1867–1947). The stylized forms, flattened perspective, and bright colors that characterized the work of these artists confirmed for Prendergast his own developing style.

Prendergast's style also bears some relation to that of the neo-impressionist Georges Seurat (1859–1891). Prendergast never met Seurat, who died the year Prendergast arrived in Paris, but the American had the opportunity to see the Seurat retrospective held at the Salon des Indépendants in 1892. The rich color relationships and magical effects made possible by the Frenchman's pointillist methods would have fascinated the American painter.

Although Prendergast was not a theorist, he was greatly impressed by the force of so many new directions in painting. By the time he returned to Boston in the winter of 1894–1895, he had assimilated many post-impressionist techniques and had developed a style in which discretely balanced color patches created prismatic and scintillating effects.

For more than a decade after his return to Boston, Prendergast worked principally in watercolor. The New England beach scenes (1895–1898), the Italian piazzas and canals (late 1898–1899), and the Boston and New

York park scenes (1900–1906) comprise a stylistically unified group. For the most part, they are crowded figure compositions placed against a strong architectural backdrop. Set in a flattened space, the figures, individually characterized by details of dress and expression, move horizontally across the picture plane. They are painted in distinct patches of pure color, initially with a pastel palette and later (after his trip to Italy in 1898) in bolder, more contrasting hues.

During the summer of 1896, Prendergast looked to the beaches and piers just north of Boston for holiday subjects. One of his favorite sites was Revere Beach, where he painted pictures of women walking with parasols or reclining on the sand (Figs. 1 and 2). More athletic subjects are shown wading off rafts a few yards out to sea (Fig. 3). Each scene is rich in anecdotal detail: the swirl of a lady's dress, the shape of her hat, a child's bright red sash, another's long ponytail, the tentative expression of a young girl with her feet in the cold water. Such workaday details bring a whimsical charm to every scene.

In all of these pictures, Prendergast's palette is cool and translucent. His painterly interest is in gradations of tone, sometimes highlighted by a bright splash of color (Figs. 1 and 2) or by a blank patch of paper showing the whiteness of a young girl's dress (Fig. 4). His handling varies from relatively broad washes (Figs. 2 and 4) to increasingly tightly knit color patches enlivened by tiny slivers of untouched white paper (Fig. 3).

During this period, Prendergast produced a large body of work in monotype, and some of the characteristics of his prints found their way into his watercolors. A group of picnickers in the Boston Garden is painted in muted colors laid on in thin, inklike washes and framed by a border in the manner of a print (Fig. 5). Figures seated toward or away from the viewer, or in sharp profile, lend a flat, two-dimensional aspect to the composition. Pictures like *Picnic, Boston Garden*, in which figures are both stylized and expressive, and in which flatness is such a prominent feature, reveal Prendergast's affinity in the mid-1890s with Bonnard and the other members of the Nabis.

Europe had had a liberating effect on Prendergast in the early 1890s. The same was true when he made his third trip abroad in the summer of 1898. This time he stayed for over a year, and his travels took him to Paris and the beaches of St. Malo, and then to Italy. While Paris had offered Prendergast, the student, a stimulating cultural scene, Italy—especially Venice—offered Prendergast, the mature painter, splendid natural and architectural settings, abundant and colorful crowds, and the art of the Venetian Renaissance.

Unlike most American artists of the period, who sought out intimate views of the city's ordinary neighborhoods and citizens, Prendergast was attracted to the Piazza San Marco and its architectural monuments. His natural inclination toward large crowd scenes offering a jumble of colors and poses found its most celebrated expression in pictures like *Piazza, San Marco* (Fig. 6). Here, the incomparable cathedral façade—glittering in mosaics, glass, carved stone, and faceted gold domes, and hung with ceremonial

flags—provides the backdrop for women hurrying with children in tow across the square and men clustered in conversation near the entrance to the church. The scene is reflected in the rain-wet pavement as a mélange of reds, greens, golds, blues, and whites. The viewer looks down at this stagelike scene across the piazza. As a result, the picture plane tilts forward, and distant space recedes up rather than back.

Drawing closer to the cathedral, the hovering perspective reveals Prendergast's command of architectural structure. In a view of the church's central portal (Fig. 7), four figures huddle before the curtained entrance; others sit or walk nearby. The double row of columns flanking the portal and the colorful mosaics and glass—impressive for their solidity and grandeur—create an amorphous abstract pattern when reflected in the watery pavement below. Reflection, with its inherent juxtaposition of hard and soft surfaces, was a favorite motif of Prendergast's, a fitting one in the midst of Venice's amalgam of stone and water.

Prendergast rarely painted interiors, but the spectacle of religious ceremony in St. Mark's Cathedral presented an irresistible challenge. In one scene, a procession is being assembled in the nave of the church in celebration of Easter Sunday (Fig. 8). In another, two acolytes flank a priest at the altar, perhaps preparing for Mass (Fig. 9). Pageantry and ritual offer an opportunity to create tessellated effects out of flickering light, stained glass, jeweled objects, and the ornate robes of the priests.

Prendergast was interested primarily in ordinary people in public scenes. Although his techniques were modernist, his views of ceremonial pomp (Fig. 8), of crowded streets (Fig. 10), of architectural monuments (Fig. 11), and of Venice's watercraft (Figs. 12 and 13) are in the tradition of the city's own earlier painters such as Vittore Carpaccio (c. 1456–c. 1525) and Gentile Bellini (1429–1507).

A passage in Prendergast's 1898 sketchbook reads simply, "Carpaccio Vittore, Venezia." He discovered the art of this Venetian master of genre painting while wandering in the Accademia and in the Scuola di San Giorgio degli Schiavoni. *The Legend of Saint Ursula* in the Accademia and the frieze of paintings in the Schiavoni that illustrate stories of the three protectors of Dalmatia demonstrate Carpaccio's strong architectural sense, his rigorous perspective, and his relentless exploration of the world in which he lived. All of the characteristics that mark the Venetian school are magnified in his work: a love of color arranged in intricate patterns, an appreciation of the surfaces of rich materials, a taste for the exotic and fantastic, wit and humor in gesture and pose, the pomp and pageantry of the State, and an insatiable curiosity about Venice itself. Bellini's *Procession in Piazza San Marco* in the Accademia celebrates Venice's state ceremony as well as the earthy idiosyncrasies of her citizens. Each pose and gesture is revealing of its owner's state of mind.

Prendergast delighted in the Venetians' color and subject matter, and his own later works in Venice reflect the influence of these masters. While pictures such as his delicate and relatively broadly painted *Riva degli*

Schiavoni (Fig. 14) relate stylistically to his earlier Revere Beach series, the warmer-toned and patternistic pictures like *Piazza, San Marco* and *The Grand Canal, Venice* (Fig. 15) were apparently painted during the spring and summer of 1899 and reflect the example of his Italian predecessors.

Prendergast's stay in Venice was broken periodically by trips to other Italian cities. These include Padua, with its celebrated fresco cycle by Giotto in the Scrovegni Chapel; Orvieto, famous for the magnificent mosaics adorning its cathedral façade; and Siena, where Ambrogio Lorenzetti's series of allegorical paintings on Good and Bad Government decorate the Palazzo Pubblico. In Siena, Prendergast was attracted by the city's narrow streets and houses crowded together in picturesque disorder. In one watercolor, a Sienese woman approaches the viewer carrying a basket on each arm (Fig. 16). The time-darkened buildings and a succession of archways behind her convey the city's medieval appearance. A different aspect of the city is portrayed in a watercolor of the busy Campo Vittorio Emanuele on a rainy day (Fig. 17). Like the Piazza San Marco in Venice, the Campo is crowded with figures: housewives carrying baskets and umbrellas, young women, old men, a pair of *carabinieri* in uniform. A few passers-by pause to stare at the viewer, but most continue on their way. Three old women on a second-story balcony at the far side of the square overlook the busy scene. Below the balcony, some of the figures pass through an arched opening leading out of the Campo. The seemingly random view of citizens carrying on their daily business set against a looming architectural backdrop might have been called *The Results of the Good Government of Siena*, the title of a strikingly similar scene by Lorenzetti in the Palazzo Pubblico.

Prendergast spent the winter of 1898–1899 in Rome. One of his favorite venues was the Pincian Hill, crowded with citizens and visitors enjoying evening promenades and concerts of the military bands that played there. In two closely related views, elegant horse-drawn carriages proceed down the hillside thronged with pedestrians (Figs. 18 and 19). The colorful pageant has a frozen, static quality reminiscent of quattrocento Italian art. There are always members of the clergy in the crowds, and Prendergast was especially delighted with the Germans and the Hungarians, who wore red gowns (Fig. 20).

His travels took him as far south as Naples and to Capri. Known for its bold, picturesque scenery, the island has long been a favorite resort of artists. Its terraced hills and flat-roofed houses are the setting for a dreamy, idyllic landscape in which figures are arranged friezelike amid blossoming trees and flowers (Fig. 21). The picture reveals a number of traditions that influenced Prendergast, from Italian fresco painters and mosaicists to nineteenth-century symbolist painters like Puvis de Chavannes. Always present is the whimsy and charm of Prendergast himself, whose leaping dog in the foreground could be a descendant of one of Carpaccio's animals.

Prendergast returned to Boston in late fall 1899. He began exhibiting his Italian pictures and met with increasing public and critical acclaim. During the first decade of the new century, he continued to work primarily in watercolor, and another subject emerged to replace the festive gaiety of Europe's urban scene:

the parks and avenues of Boston and New York. The May Day celebrations in Central Park are composed with all the detailed complexity of his late Venetian scenes (Figs. 22–24); Madison Square is frequented by the same horse-drawn carriages and well-dressed strollers as the Pincian Hill (Fig. 27); a millinery shop on Columbus Circle in New York with its passing parade (Fig. 28) and a fountain in the Boston Public Garden (Fig. 29) seem transposed from the boulevards and parks of Paris.

The park scenes brought to a climax the drive toward densely packed compositions that had marked Prendergast's watercolors for several years. When he returned to the subject of New England beaches in 1903–1904, he used fewer figures and many of them are more abstract than ever before (Figs. 35–37). The rocky shores of Nahant and Cohasset are populated by featureless figures whose parasols are now free-floating circles in red and orange.

Prendergast traveled to France in May 1907 and was in Paris by the first of June. He had come to refresh his eye. In one letter he remarks that "it would pay any artist just to come over and look around" adding that "the exhibitions are the great thing here. . . . I learn more from them than anything else." He was most impressed by the works of Cézanne, who had died the year before. Cézanne's watercolors were exhibited at Galerie Bernheim-Jeune in late spring 1907, and he was given a retrospective at the Salon d'Automne in October of that year. Writing to his friend Mrs. Oliver Williams the same month, Prendergast comments that "Cézanne gets the most wonderful color, a dusky kind of grey. He had a watercolor exhibition late in the spring which was to me perfectly marvelous. He left everything to the imagination: they were great for their simplicity and suggestive quality." He concludes that "Cézanne will influence me more than the others."

Prendergast's style was undergoing a change before he left for France, and, as was often the result of his travels abroad, he found in another artist's example the impetus to pursue new directions in his own work. Cézanne's subtle tonalities and masterful use of the white paper inspired him to use a cooler palette and to open up his compositions. Several years later, when he returned to Venice and painted that city's bridges, his style became one of related tones of color applied in broken brush strokes with patches of white paper that indeed leave more to the imagination than ever before.

Prendergast's watercolors of 1896 through 1906 represent a record of turn-of-the-century public life as seen by an artist whose view of the world and of art was uniquely his own. For Prendergast, art consisted of color, pattern, balance, and movement; he chose to paint crowded beaches, piazzas, and parks because they offered those elements. Intellectual choice liberated him from the impressionist constriction of creating a record of nature. Thus, these pictures document the time in which they were produced and reflect the specific sensibility of the eye that saw and the hand that painted them.

<div align="right">

Donna Seldin
Coe Kerr Gallery

</div>

<div align="right">

Fig. 1 (opposite)
Ladies with Parasols, 1896
Watercolor, 12¾″ × 10″
Private collection

</div>

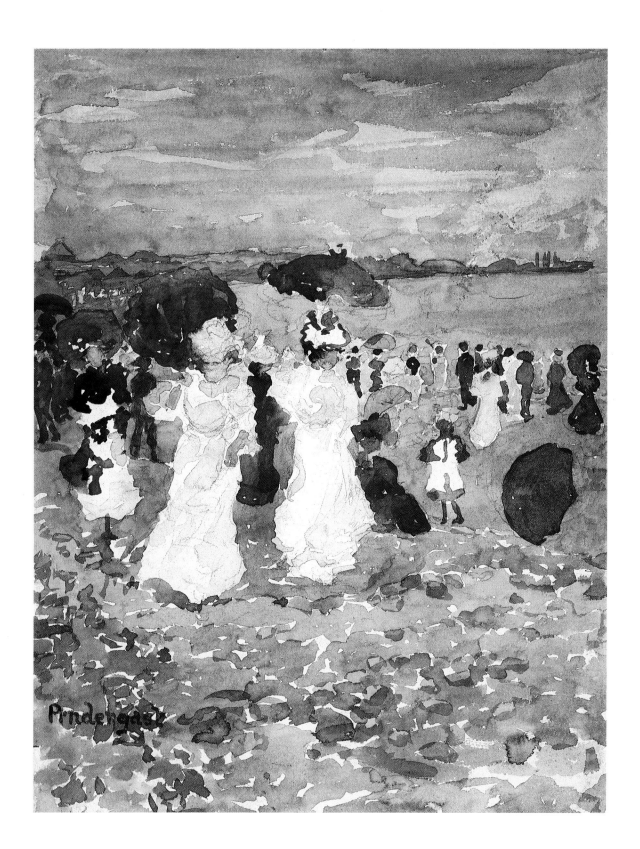

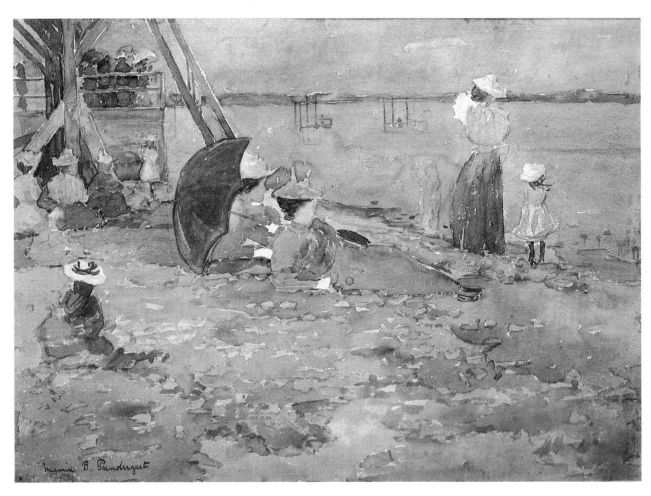

Fig. 2
Revere Beach, 1896
Watercolor, 10″ × 14″
Coe Kerr Gallery, New York

Fig. 3 (opposite)
Children on a Raft, 1896
Watercolor, 17¾″ × 13½″
Private collection

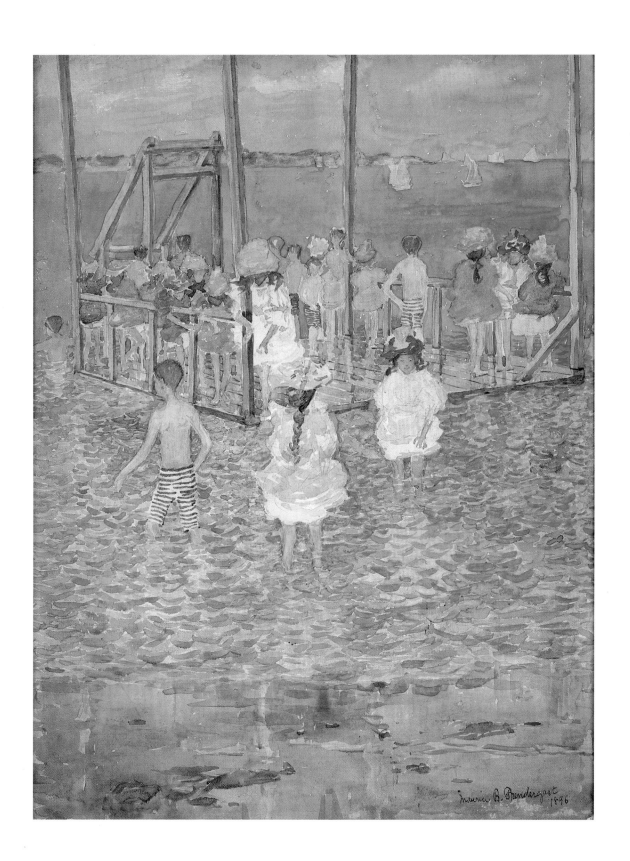

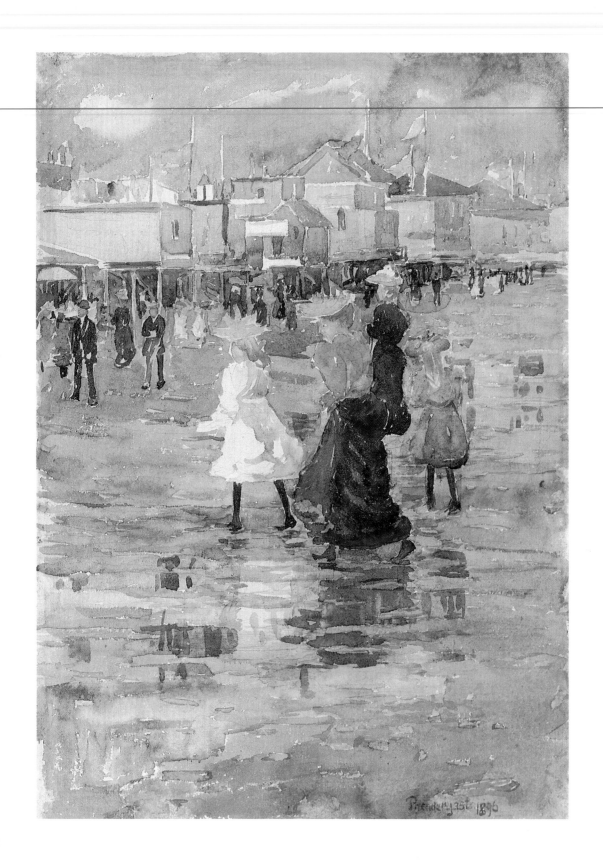

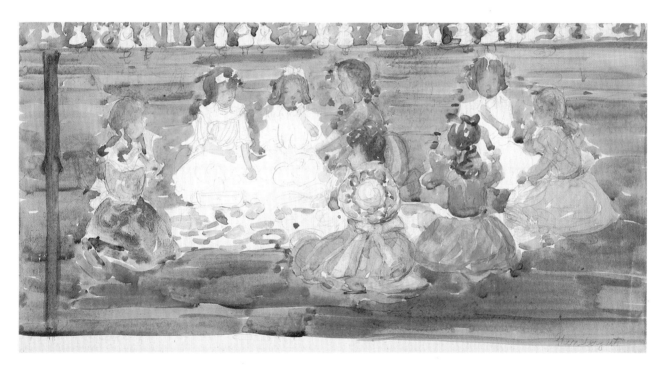

Fig. 5
Picnic, Boston Garden, 1895–1897
Watercolor, 8¾″ × 16⅝″
Collection of Mr. and Mrs. Raymond J. Horowitz

Fig. 4 (opposite)
Revere Beach, 1896
Watercolor, 14″ × 10″
Collection of Mr. and Mrs. Raymond J. Horowitz

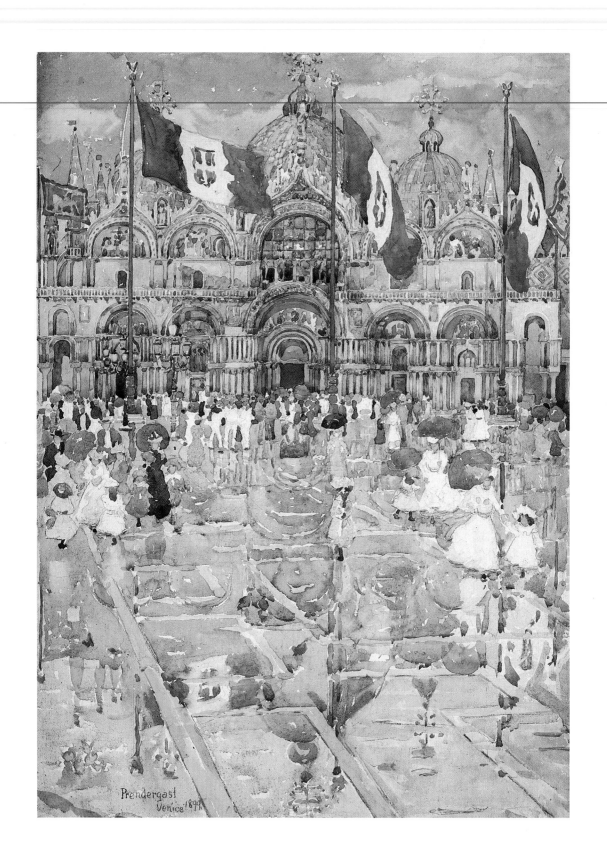

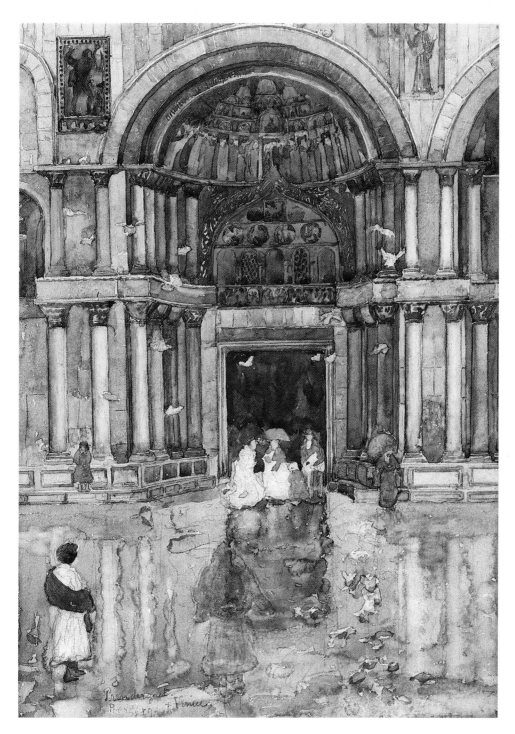

Fig. 6 (opposite)
Piazza, San Marco, Venice, 1899
Watercolor, 19⅜″ × 14¼″
Alice M. Kaplan

Fig. 7
The Porch with the Old Mosaics, St. Mark's, 1899
Watercolor, 16″ × 11¼″
Transco Energy Company, Houston, Texas

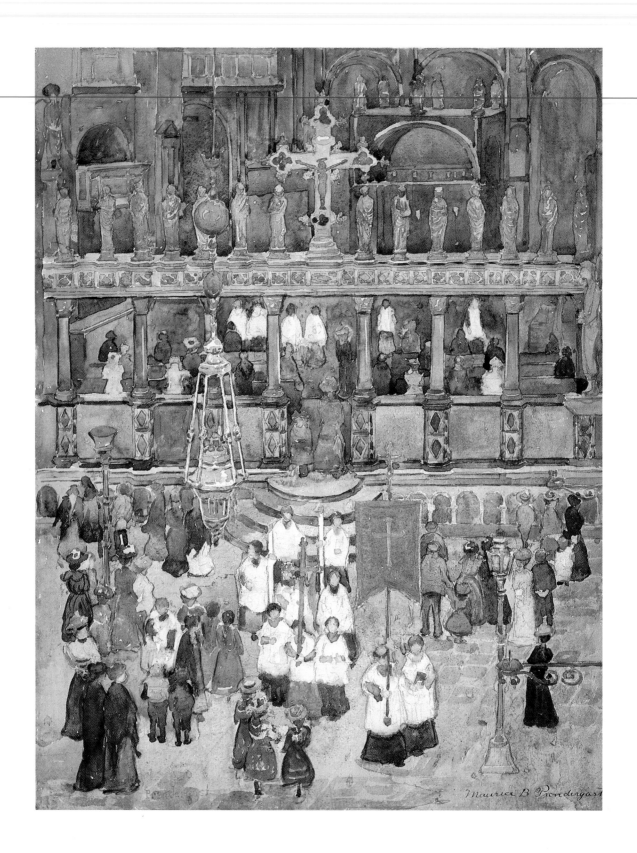

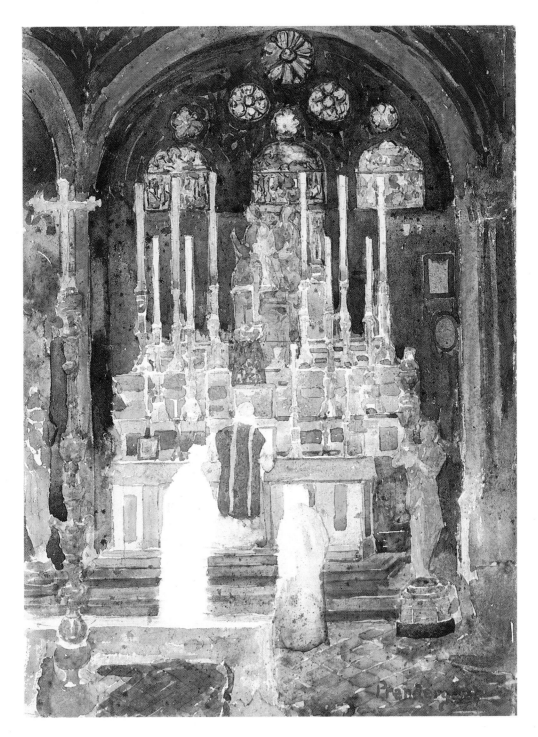

Fig. 8 (opposite)
Easter Procession, St. Mark's, Venice, 1898
Watercolor, 18″ × 14″
Private collection

Fig. 9
Interior, San Marco, 1898
Watercolor, 15″ × 11″
Estate of Robert Brady

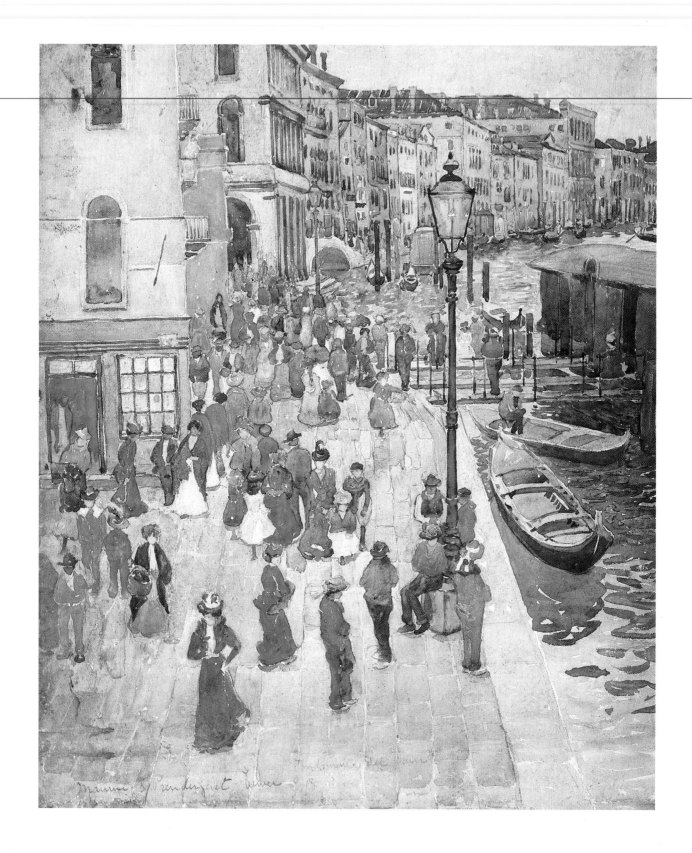

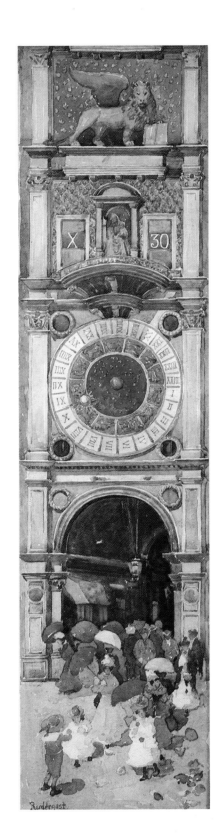

Fig. 10 (opposite)
Venice, 1898
Watercolor, 18¼″ × 15″
Collection of Rita and Daniel Fraad

Fig. 11
*St. Mark's Square, Venice
(The Clock Tower)*, 1898–1899
Watercolor, 23½″ × 5¾″
William A. Farnsworth Library and
Art Museum, Rockland, Maine

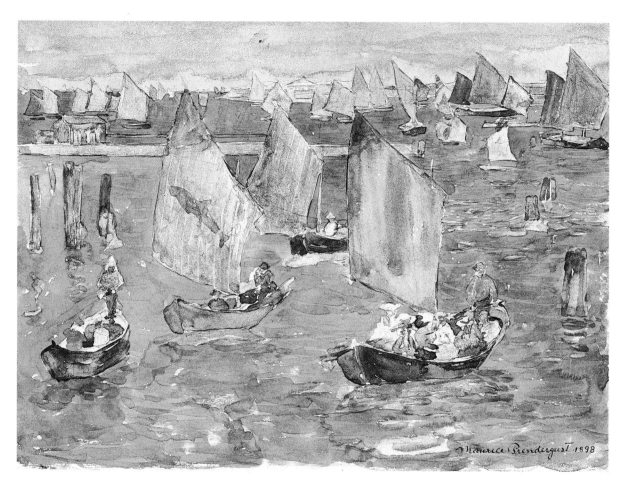

Fig. 12
The Lagoon: Venice, 1898
Watercolor, 11⅛″ × 15⅜″
Coe Kerr Gallery, New York

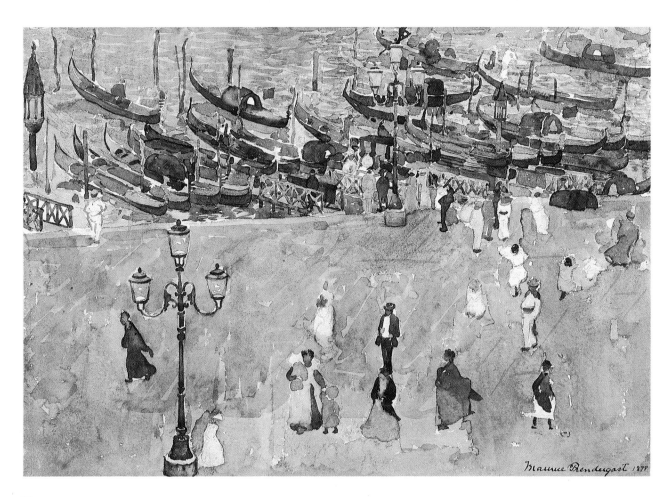

Fig. 13
Gray Day, Venice, 1899
Watercolor, 12¼″ × 18″
Private collection

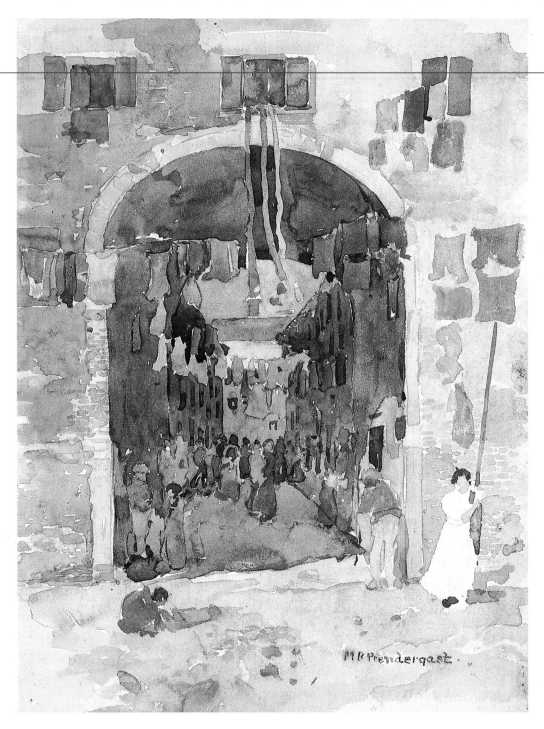

Fig. 14
Riva degli Schiavoni, 1898
Watercolor, 14″ × 10½″
Anonymous

Fig. 15 (opposite)
Grand Canal, Venice, 1898–1899
Watercolor, 17⅞″ × 14⅛″ Daniel J. Terra Collection,
Terra Museum of American Art, Evanston, Illinois

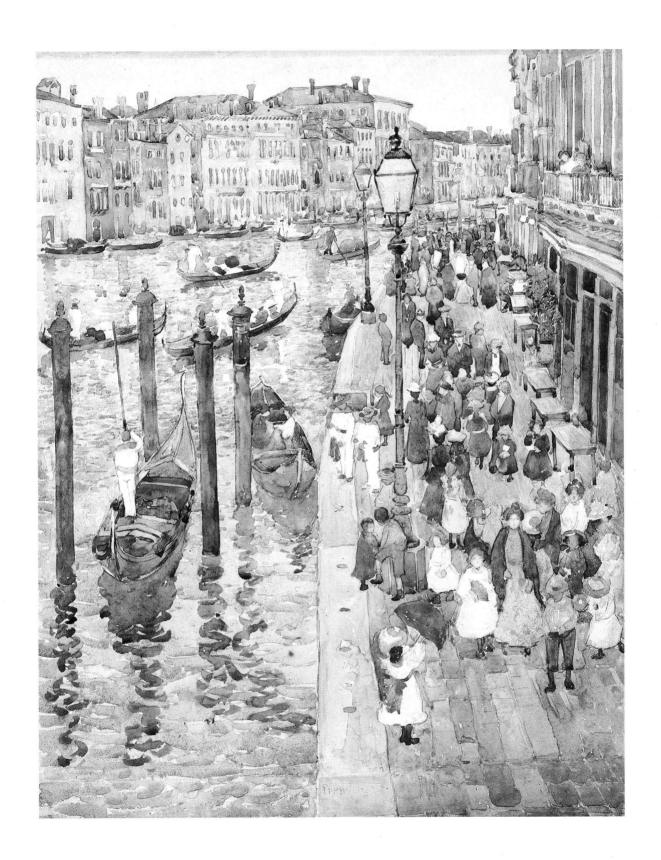

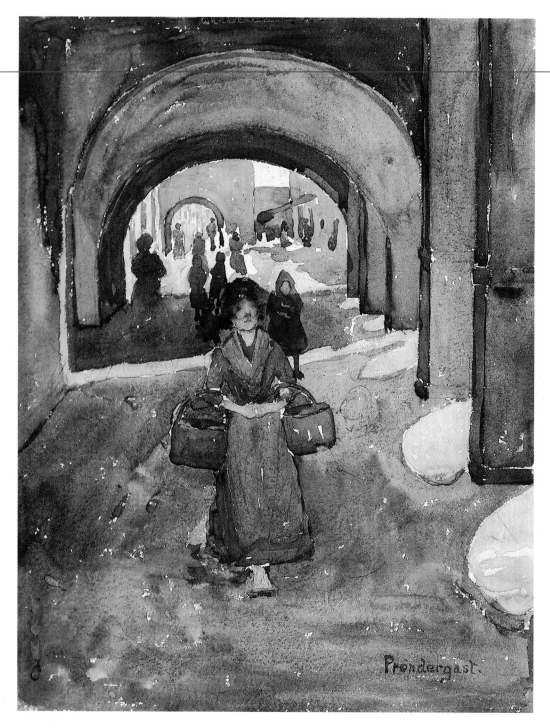

Fig. 16
Siena, 1898
Watercolor, 12¼″ × 9½″
Coe Kerr Gallery, New York

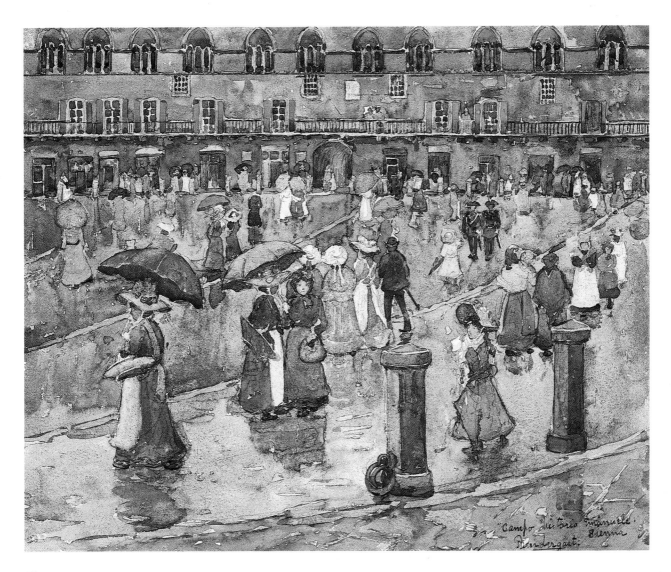

Fig. 17
Campo Vittorio Emanuele, Siena, 1898
Watercolor, 11¼″ × 13¾″
Private collection

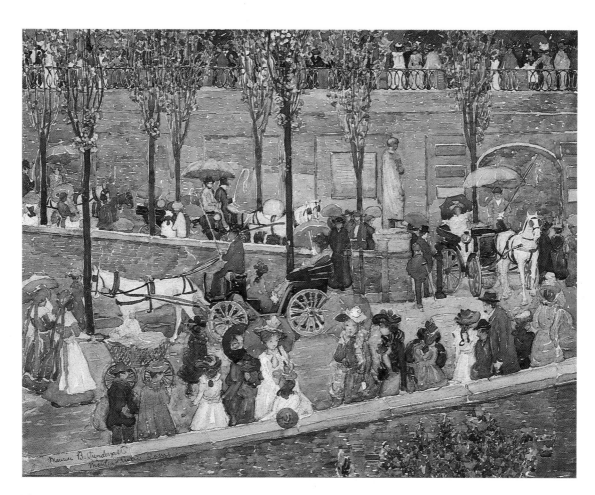

Fig. 18
Monte Pincio, Rome, 1898–1899
Watercolor, 15½″ × 19¾″
Daniel J. Terra Collection, Terra Museum
of American Art, Evanston, Illinois

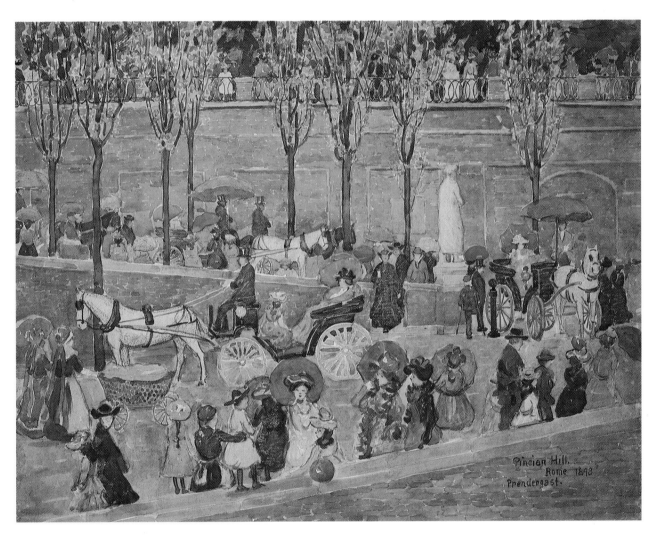

Fig. 19
Pincian Hill, Rome, 1898–1899
Watercolor, 21″ × 27″
The Phillips Collection, Washington, D.C.

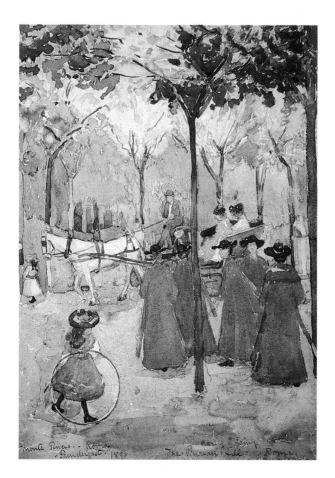

Fig. 20
Early Spring, Monte Pincio, 1898
Watercolor, 14⅞″ × 11⅛″
Private collection

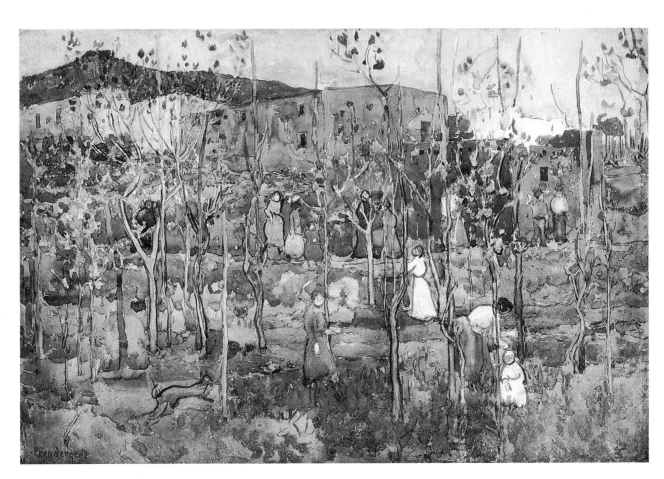

Fig. 21
Capri , c. 1899
Watercolor, 13½″ × 20″
Coe Kerr Gallery, New York

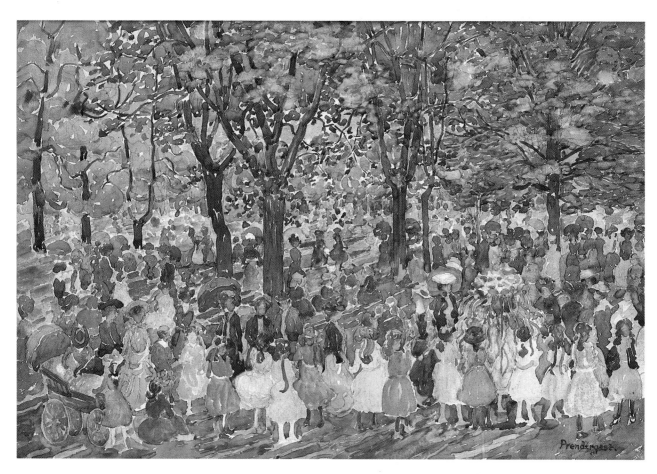

Fig. 22
May Day, Central Park, c. 1901
Watercolor, 14½″ × 21⅝″
Collection of the Whitney Museum of
American Art, New York

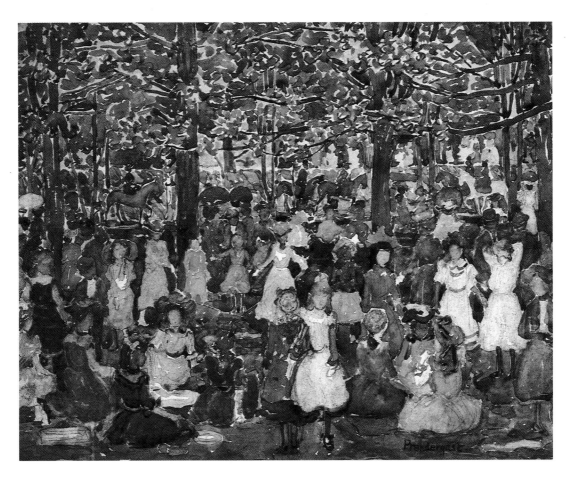

Fig. 23
Central Park, 1901
Watercolor, 15⅛″ × 19½″
Collection of the Blanden Memorial
Art Museum, Fort Dodge, Iowa

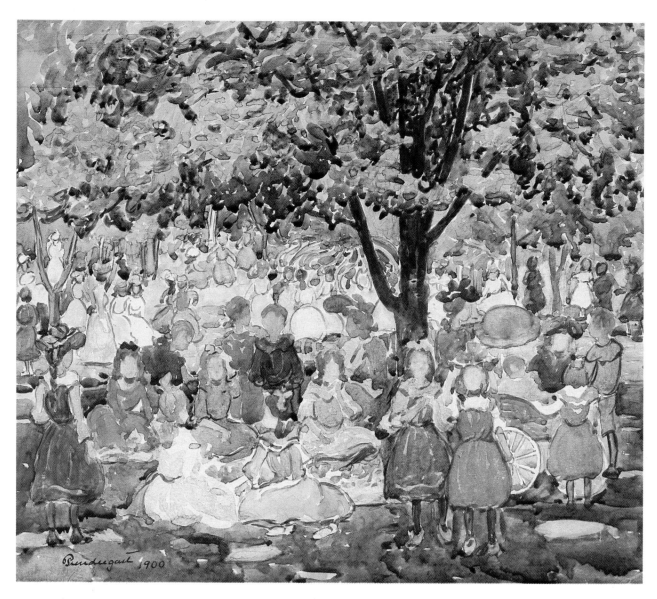

Fig. 24
May Day, Central Park, c. 1901
Watercolor, 10″ × 14″
Private collection

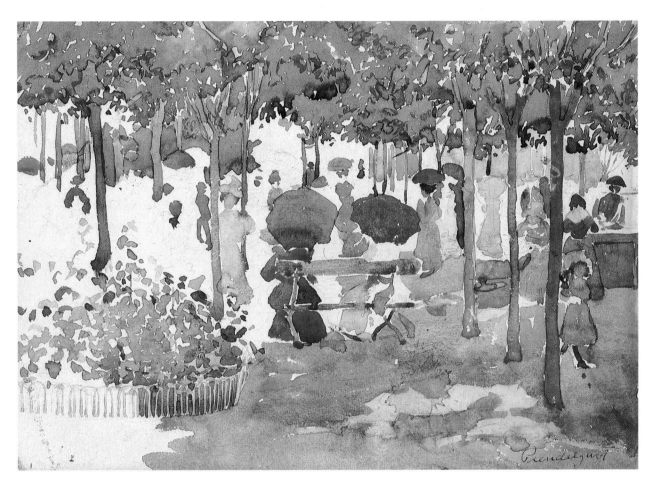

Fig. 25
Central Park, c. 1901
Watercolor, 9½″ × 13½″
Mrs. William Green

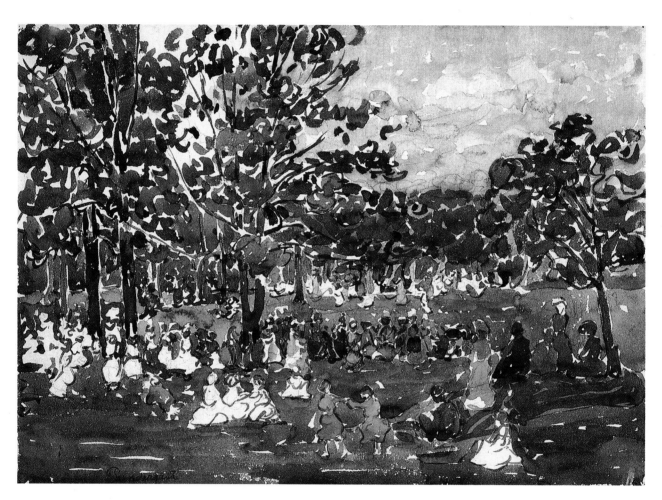

Fig. 26
Central Park, c. 1901
Watercolor, 10¾″ × 15″
Coe Kerr Gallery, New York

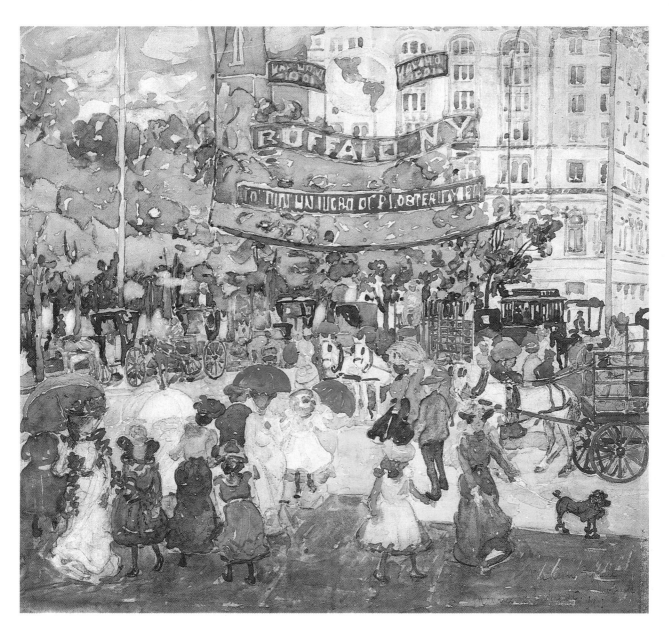

Fig. 27
Madison Square, 1901
Watercolor, 15″ × 16½″
Collection of the Whitney Museum of
American Art, New York.
Joan Whitney Payson Bequest

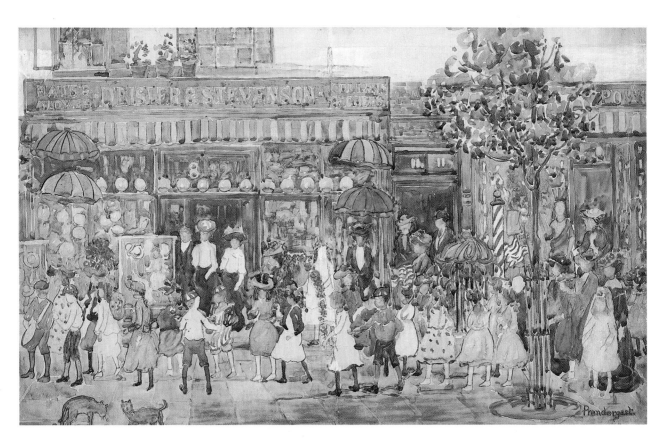

Fig. 28
Columbus Circle, New York, c. 1903
Watercolor, 14″ × 23″
Private collection

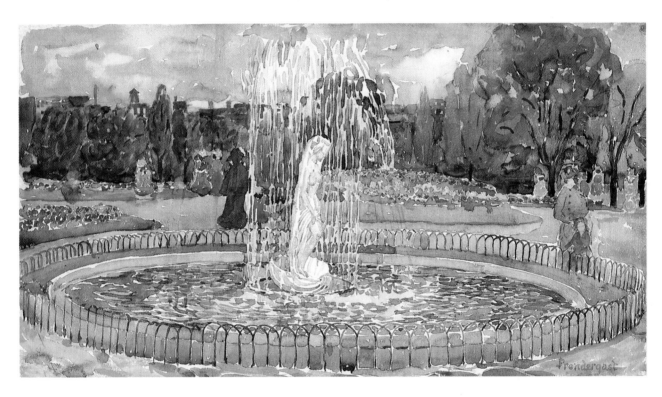

Fig. 29
Public Garden, Boston, c. 1901
Watercolor, 10″ × 18¼″
Coe Kerr Gallery, New York

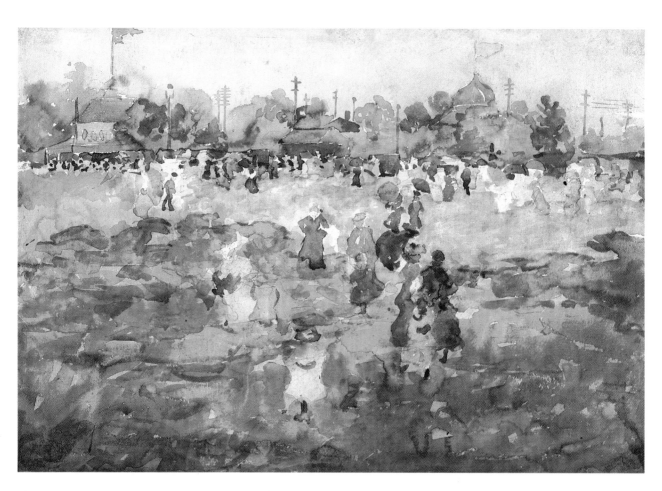

Fig. 30
Franklin Park, Boston, 1896
Watercolor, 14″ × 20″
Anonymous

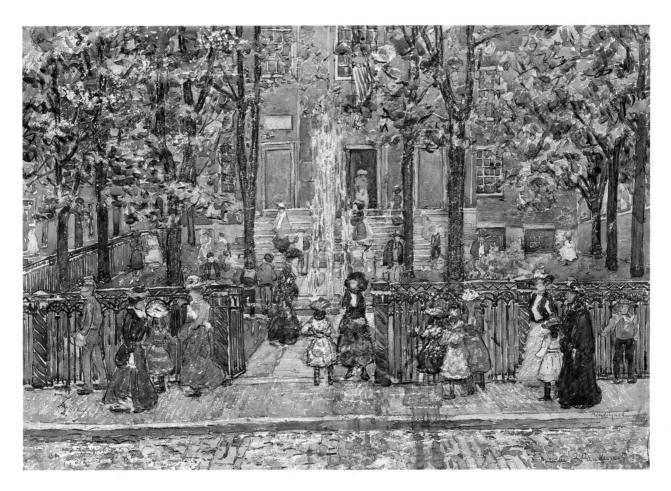

Fig. 31
Courtyard, West End Library, Boston, 1901
Watercolor, 14⅝″ × 21¼″
Lent by the Metropolitan Museum of Art, New York.
Gift of the Estate of Mrs. Edward Robinson, 1952

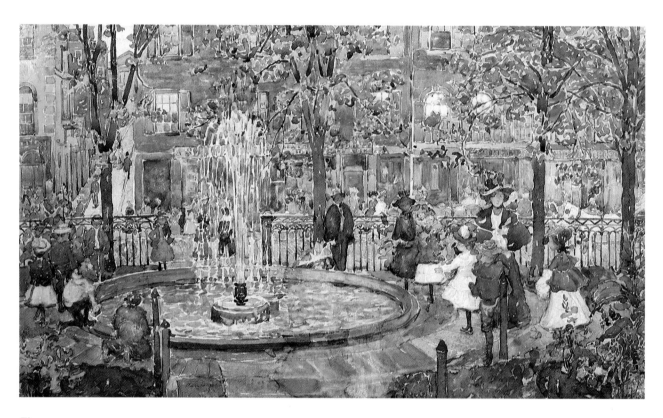

Fig. 32
Fountain at West Church, Boston, c. 1901
Watercolor, 12¾″ × 22″
Collection of Rita and Daniel Fraad

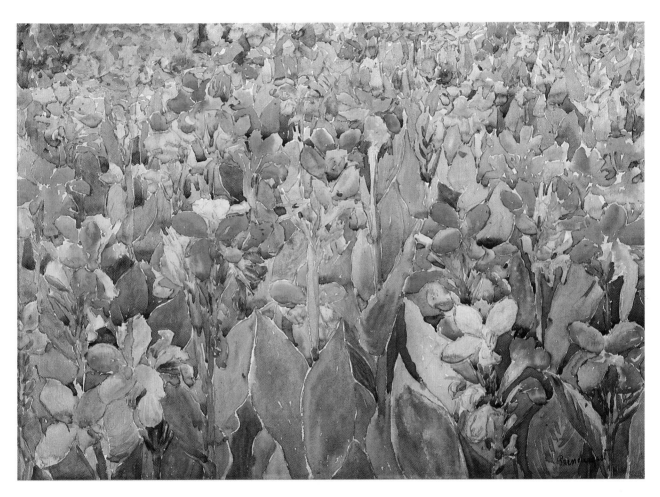

Fig. 33
Bed of Flowers, c. 1900
Watercolor, 13″ × 19¼″
Coe Kerr Gallery, New York

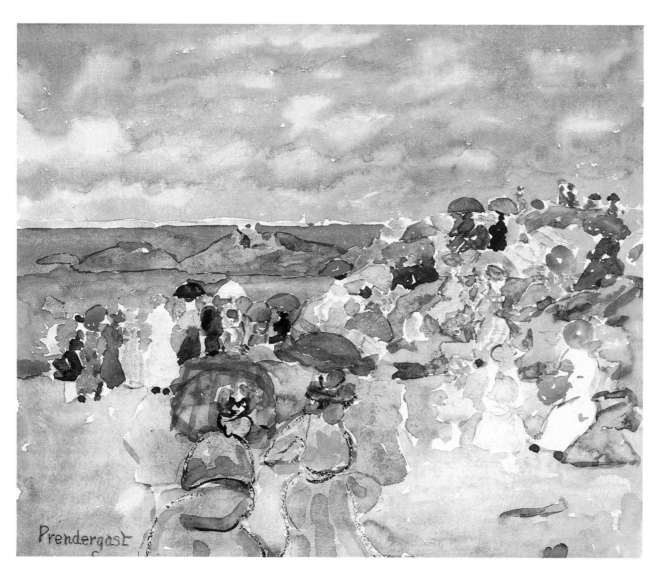

Fig. 34
Nahant, c. 1903
Watercolor, 11″ × 14″
Ms. Cornelia G. Corbett

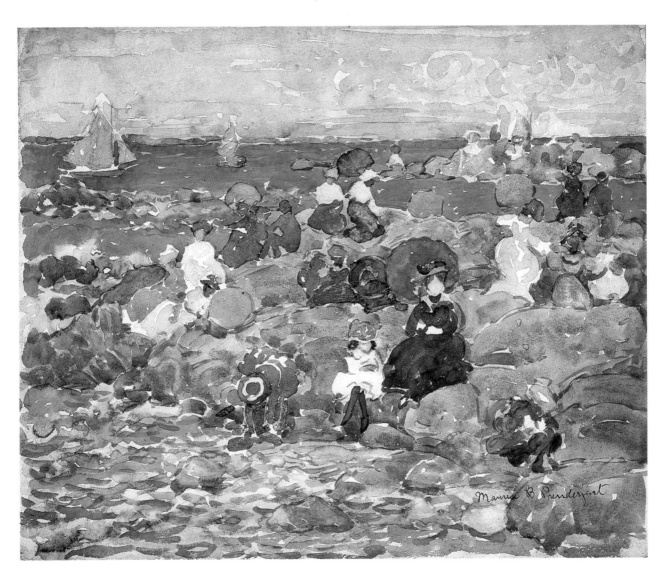

Fig. 35
Holiday, Nahant, 1903
Watercolor, 12½″ × 15½″
Anonymous

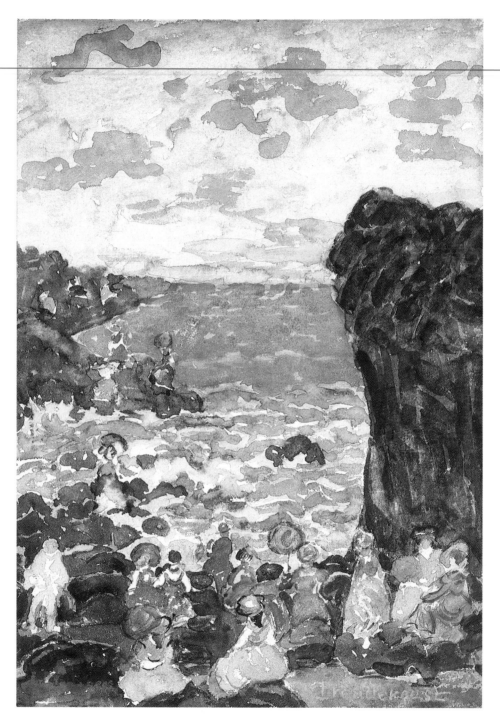

Fig. 36
Holiday Headlines, c. 1903
Watercolor, 15¼″ × 10⅞″
Private collection

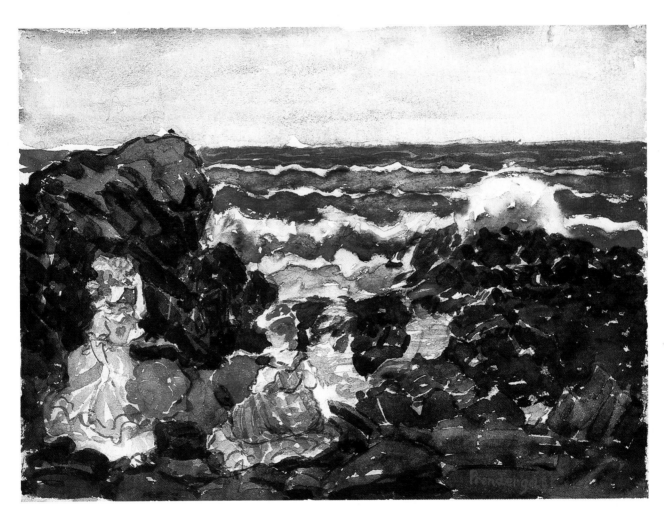

Fig. 37
Surf, Cohasset, c. 1903
Watercolor, 10¾″ × 14¾″
Coe Kerr Gallery, New York

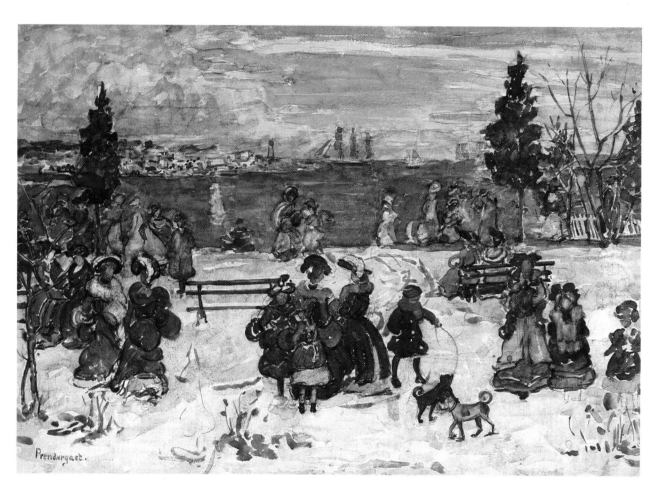

Fig. 38
April Snow, Salem, 1906–1907
Watercolor, 14¾" × 21⅝"
The Museum of Modern Art, New York.
Gift of Abby Aldrich Rockefeller (129.35)

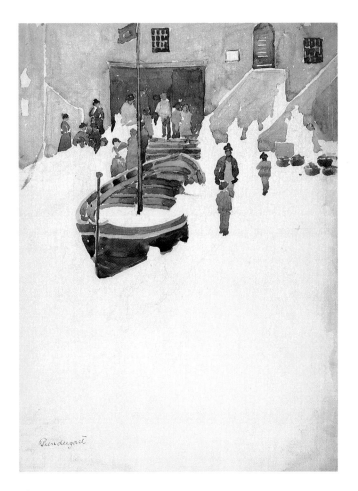

Fig. 39
Fisherman at San Malo, 1902
Watercolor, 14⅜″ × 10⅜″
Collection of John Brady, Jr.

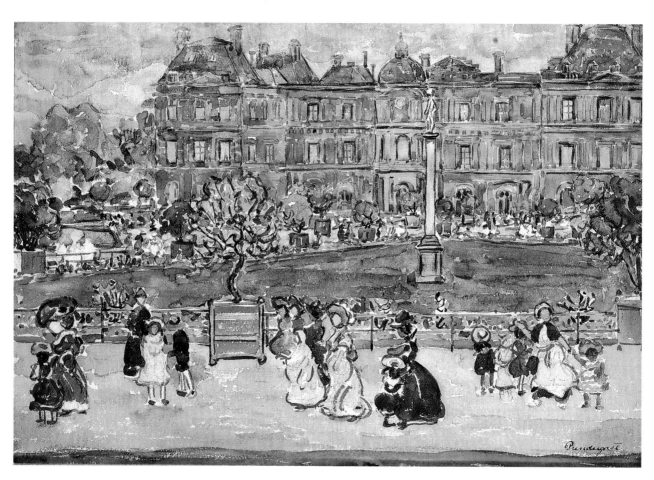

Fig. 40
Paris Scene, c. 1907
Watercolor, 14″ × 20″
Private collection